NO THOUGHTS
JUST CORGIS

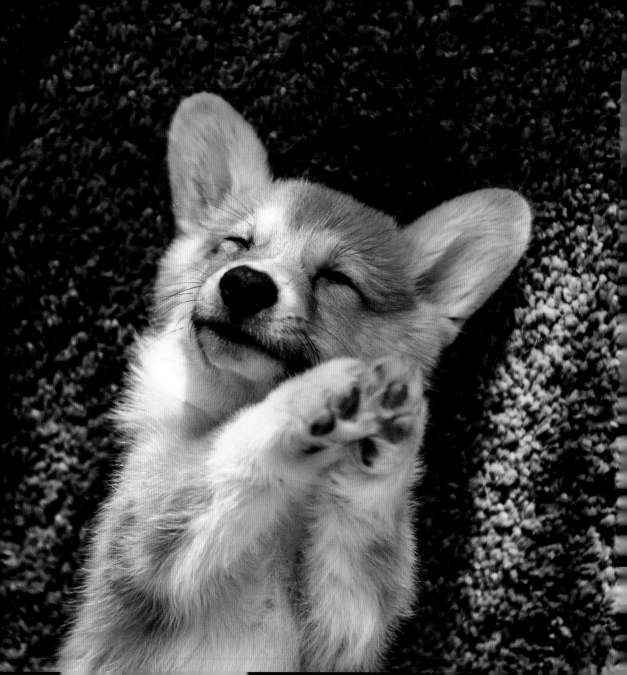

A COMPREHENSIVE COMPENDIUM OF CUTENESS

NO THOUGHTS JUST CORGIS

UNION
SQUARE
& CO.

NEW YORK

U

UNION
SQUARE
& CO.

NEW YORK

UNION SQUARE & CO. and the distinctive Union Square & Co. logo
are trademarks of Sterling Publishing Co., Inc.

Union Square & Co., LLC, is a subsidiary of Sterling Publishing Co., Inc.

ISBN 978-1-4549-5185-8
ISBN 978-1-4549-5186-5 (e-book)

Library of Congress Control Number: 2023932234

For information about custom editions,
special sales, and premium purchases, please
contact specialsales@unionsquareandco.com.

Printed in China

2 4 6 8 10 9 7 5 3 1

unionsquareandco.com

Cover design by Melissa Farris
Interior design by Christine Heun
Cover Image: Topi the Corgi

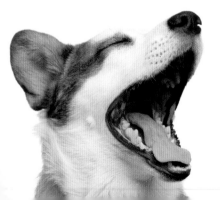

WHEN SOMEONE ASKS ME HOW I'M HANDLING EVERYTHING.

ONE DOES NOT SIMPLY
HOWL AT THE MOON.

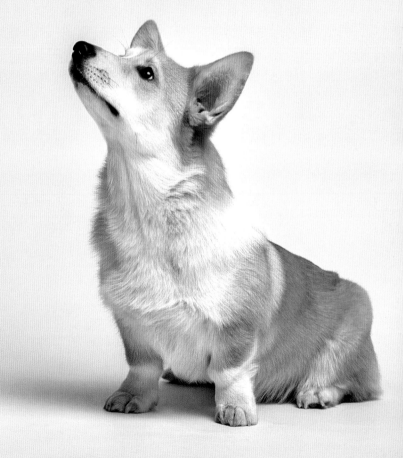

WHEN YOU *DON'T* CHASE THE DEER AND YOU GET CALLED A GOOD GIRL.

PUMPKIN SPICE TIMES INFINITY.

COOL STORY, BRO.

WHEN YOUR CORGI SMELLS ANOTHER CORGI ON YOU.

PLAYS OREGON TRAIL ONCE....

WHEN YOU REALIZE THE DOG THAT ATE YOUR HOMEWORK IS YOU.

CHOOSE
YOUR
FIGHTER

CODE NAME: SILENT FURY

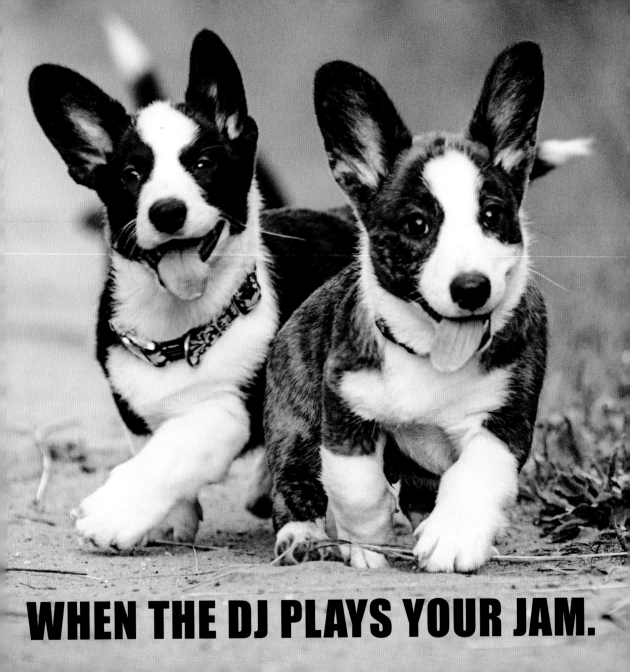

SWIPE RIGHT,
SWIPE RIGHT,
PLEASE
SWIPE RIGHT!

HANGING WITH YOUR FAMILY, WONDERING IF YOU WERE SWITCHED AT BIRTH.

SMOKE
+ SHOW
———————
= ME

I'M LIKE A THEATER—
COME TO ME FOR THE DRAMA.

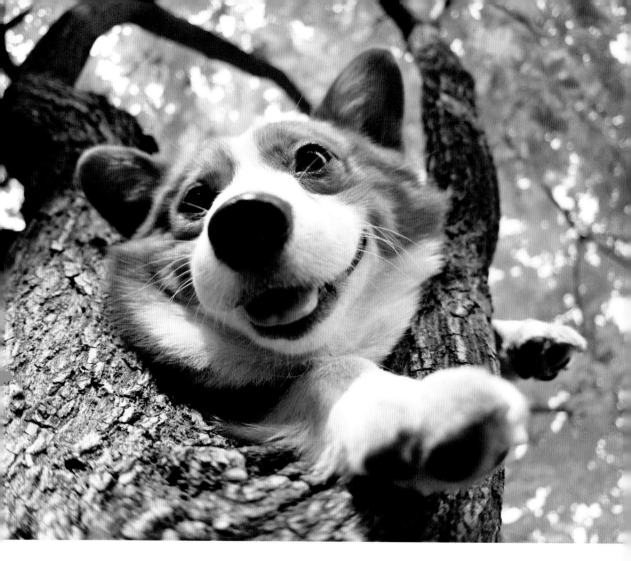

**TO CATCH THE SQUIRREL,
ONE MUST BECOME THE SQUIRREL.**

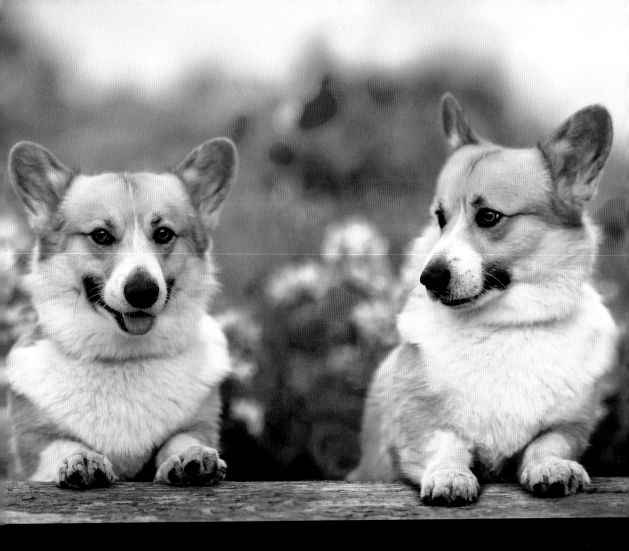

**WHEN YOUR FRIEND STARTS
FLIRTING WITH THE BARTENDER.**

HOMIES
FOREVER

HOW DO YOU DO, FELLOW KIDS!

I AM A STUDENT OF LIFE.

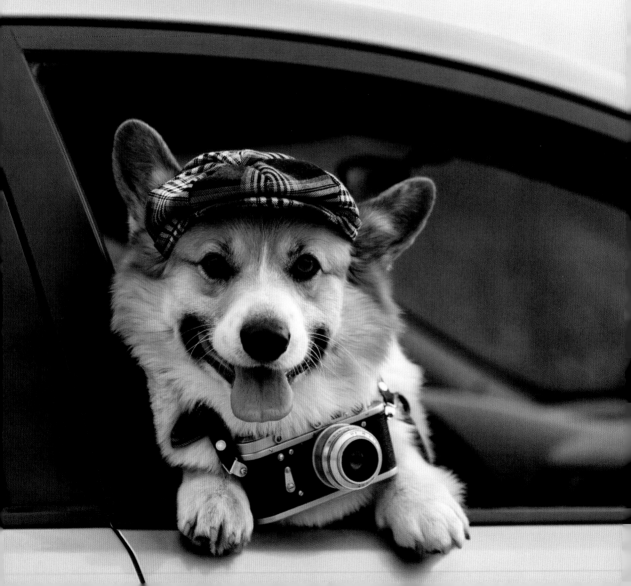

WHEN SOMEBODY SAYS
YOU LACK POISE.

WORLD'S WORST
WINGMAN

COME PLAY WITH US FOREVER AND EVER AND EVER.

STEP ASIDE, RONALDO.

WHEN THE DOWAGER DUCHESS OF BOLTON SAYS

YOU SIP TEA LIKE A PEASANT.

HOW LONG DO I HAVE TO WAIT TO REGIFT THIS HAT?

UNDERCOVER
OPERATIVES

WHEN YOU FORGET TO MUTE ON THE ZOOM CALL.

WE'RE TWO ADULTS, WHY CAN'T WE ADMIT WE BOTH MADE MISTAKES?

I TORE UP THE COUCH, YOU LEFT A COUCH IN THIS ROOM. EVEN STEVEN.

ABG
ALWAYS
BE
GRATEFUL?

NOPE.
ALWAYS
BE
'GRAMMING.

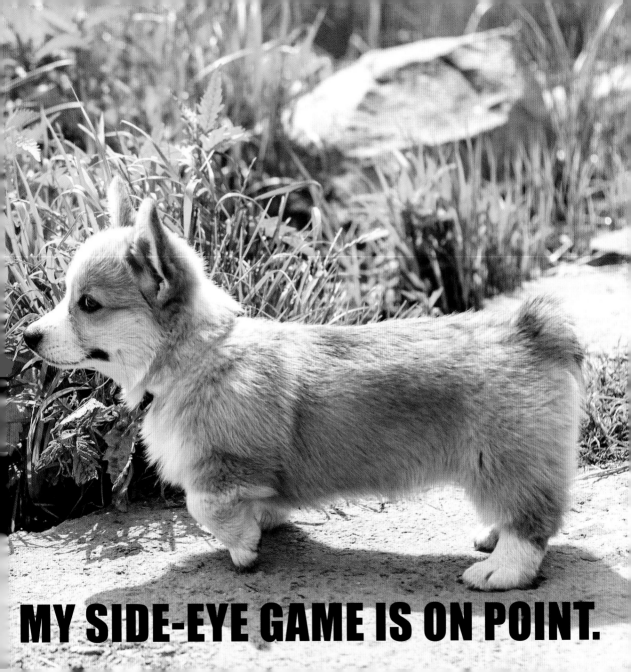

MY SIDE-EYE GAME IS ON POINT.

GREAT START TO BRUNCH, BUT I WAS PROMISED A BOTTOMLESS MIMOSA.

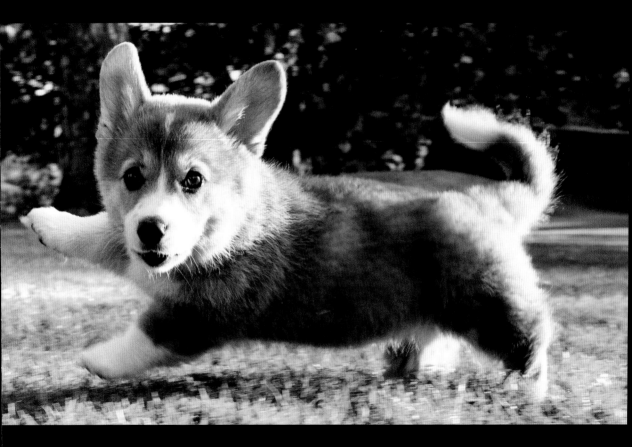

Name: PETULA BARK

Age: 4

Hobbies: SUDOKU, CRIPPLING ANXIETY, REFLEXOLOGY

Catchphrase: "I'M MARRIED TO MY WORK, BUT I WANT A DIVORCE."

TFW YOUR ROOMMATE "BORROWS" YOUR SCARF.

EVERY 8-YEAR-OLD ON SCHOOL PICTURE DAY.

EVERY 8-YEAR-OLD ON SCHOOL PICTURE RESHOOT DAY.

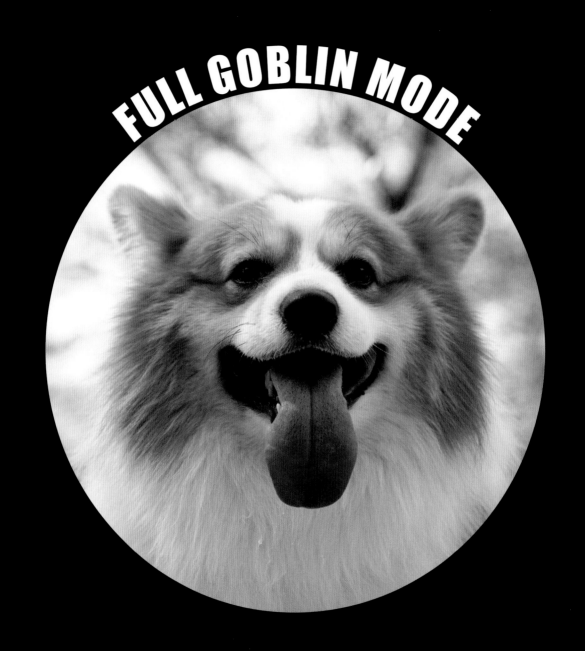

MINIMUM ALTITUDE
MAXIMUM EFFORT

KILLING TWO HEADS WITH ONE PILLOW.

CROSS ME AND I WILL BURY YOU.
YOU *AND* YOUR FAMILY.

RE: YOUR EMAIL

I AM CURRENTLY AWAY FROM THE OFFICE. I WILL REPLY TO YOUR MESSAGE AT SOME POINT IN THE NEXT 2–7 DOG YEARS. IF YOU NEED IMMEDIATE ASSISTANCE, PERHAPS TRY CONTACTING

SOMEONE WHO IS NOT A DOG.

CHOOSE WISELY: PLAYTIME, OR . . . PLAYTIME.

Q:
WHAT AM I EVEN DOING WITH MY LIFE?

A:

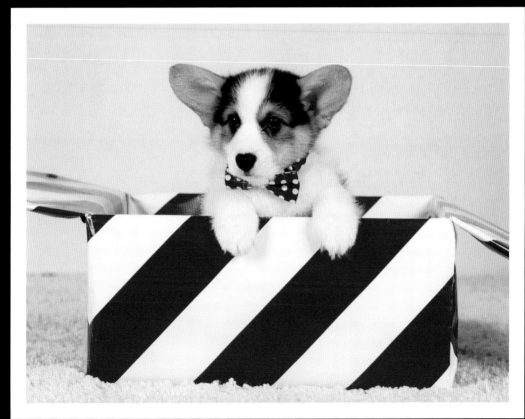

WHEN A FRIEND
IS TALKING ABOUT
THEIR RELATIONSHIP,
BUT ALL YOU CAN
THINK ABOUT IS
THE EVENTUAL
HEAT DEATH OF
THE UNIVERSE.

SLIDING INTO
YOUR DMS LIKE . . .

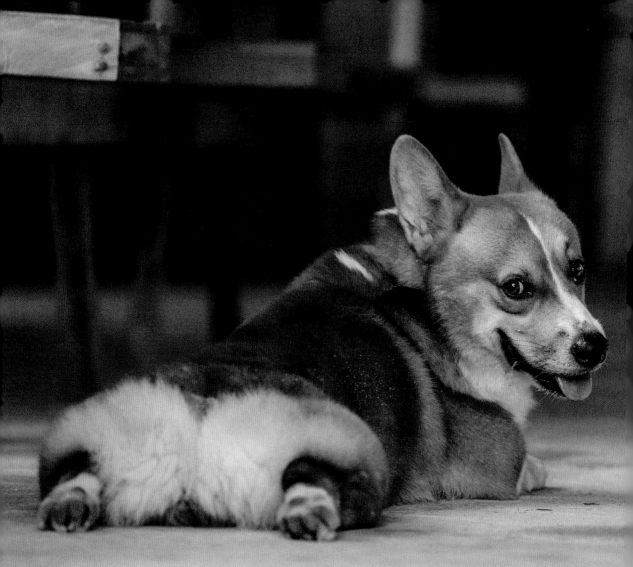

DROP IT LIKE IT MIGHT BE
SORT OF MAYBE HOT, I GUESS?

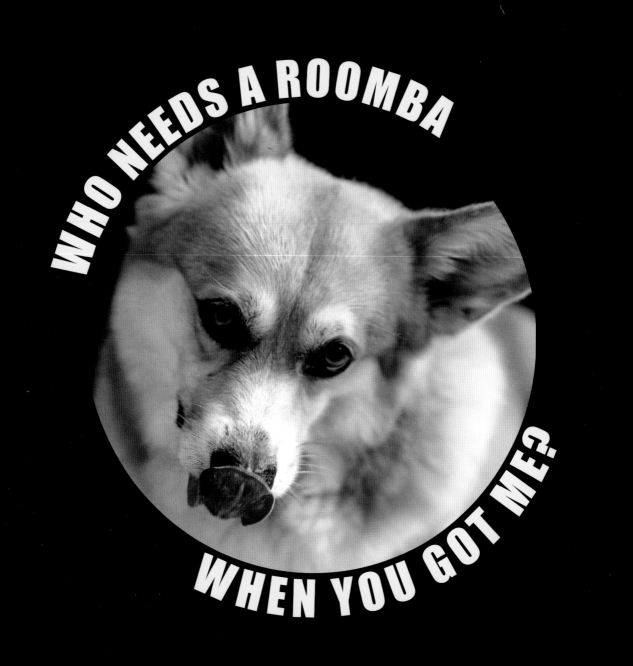

TRAFFIC STOPPIN'
RHYMES A'POPPING

WHEN THE JAM BAND AT THE BAR ANNOUNCES A THIRD ENCORE.

YOU CALL IT STUPIDITY;
I CALL IT ZEN.

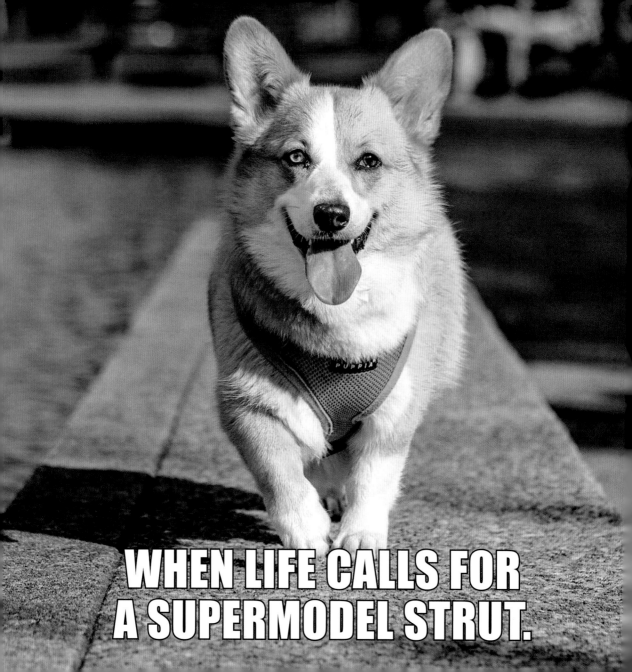

WHEN LIFE CALLS FOR
A SUPERMODEL STRUT.

WHEN IT'S AUGUST AND YOU'VE ALREADY GOT YOUR HALLOWEEN COSTUME READY.

I'M WHAT YOU'D CALL AN ARMCHAIR SUPERHERO.

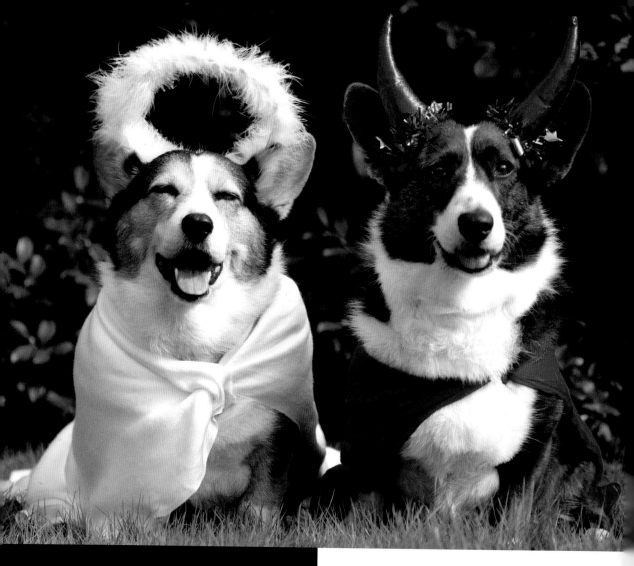

**FIG 1:
FRIDAY, 4:59 PM**

**FIG 2:
FRIDAY, 5:02 PM**

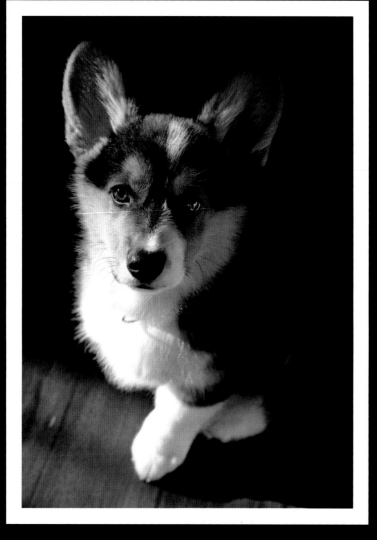

I'M ONLY AS MOODY AS MY LIGHTING.

WHEN YOUR CORGI KNOWS MORE
ABOUT TAX EXEMPTIONS
THAN YOU DO.

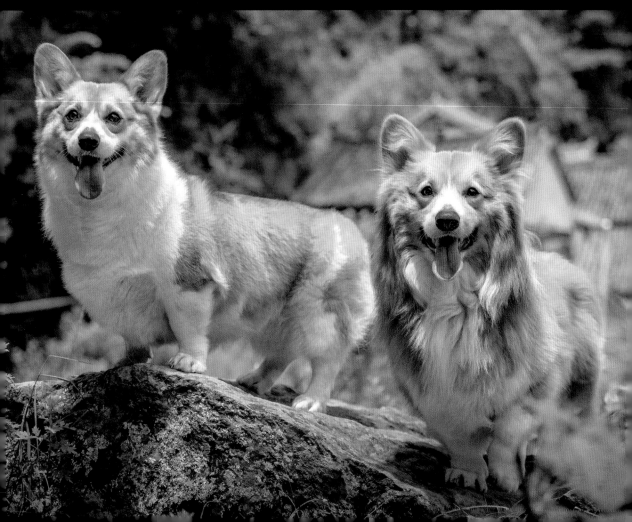

YOU GOT
99 PROBLEMS?
I GOT ZERO.

I'LL WAKE WHEN I'M DEAD!

I HEREBY KNIGHT YOU SIR GUY WHO GIVES ME FOOD. CONTINUE YOUR SERVICE FOR THE CROWN UNFLINCHINGLY.

WHEN YOU COSPLAY
AS A CAT.

I'LL JUST BE OVER HERE, PUTTING OUT THE VIBE.

YES,
IT'S ME
YOU'RE
LOOKING
FOR.

HAVE YOU BEEN INJURED ON THE JOB? OUR TEAM OF CRACK LITIGATORS AT NIBBLES, NIBBLES, JARNDYCE, AND POOCHIE ARE WAITING FOR YOUR CALL!

BELLY MEET FIRE.
SMACK MEET DOWN.
BOO MEET YAH!

**5 MILES IN,
READY TO CARBO-LOAD.**

READY TO ASK HIM TO PROM.

DEAR LADY AND/OR SIR,

PLEASE NEVER *EVER* GO TO WORK AGAIN.

WHEN
SELFIES
GO
WRONG.

Name: **DOTTIE**
Date of Birth: **YESTERDAY**
Dream Job: **POSING FOR INSPIRATIONAL CALENDARS**
Actual Job: **ACCOUNTS PAYABLE**

HERE COMES YOUR CRUSH—ACT NATURAL!

WE'VE PUT OUR BEST PEOPLE ON IT.

WIGGLES
HAS
ENTERED
THE CHAT.

CAN YOU DEAL WITH MY INFINITE NATURE?

ME HIDING FROM
MY RESPONSIBILITIES.

MY RESPONSIBILITIES, LOOKING FOR ME.

STAY
HANGRY.

WHEN YOU CAN'T REMEMBER THE SECOND VERSE OF "JINGLE BELLS," SO YOU JUST SING GIBBERISH.

WHEN YOUR NEW YEAR'S EVE PARTY ENDS IN APRIL.

23,000 YEARS OF SELECTIVE BREEDING HAVE ALL LED UP TO THIS MOMENT.

Name: **HENRIETTA THE YOUNGER**
Happiest Moment: **MEETING THE QUEEN**
Saddest Moment: **BARFING ON THE QUEEN**

YACHT ROCK
STATE OF MIND

BACK THE TRUCK UP.

WHEN YOUR SUBCONSCIOUS SENDS YOU A GIFT BASKET.

Image Credits